Calming Designs

Adult Coloring Book

21 images for relaxation and creativity

Copyright © 2017 Anca Andrei, Alexandra Andrei

All rights reserved.

ISBN-10: 1544847165
ISBN-13: 978-1544847160

FOREWORD

In this book, you will find 21 beautiful images to color however you like. Each coloring page is printed on a separate sheet to avoid bleeding through if you use markers. Between them you will find empty sheets, that will protect the next image from markers staining. If your pencils or your markers didn't pass through the page and those sheets of paper are still blank, you can doodle on them and draw all your worries away.

It is indicated to use colored pencils, because you can blend colors and do more complex artworks. Try to find some pencils with vivid colors, they are a pleasure to use.

Although coloring relieves stress, not only stressed people have benefits from coloring. All of us need color and beauty in our lives and coloring is something that brings pleasure and happiness into our souls. You can find beauty and relaxation in this activity.

When you start coloring, try to put your phone on silent and take your time to concentrate on the beauty of your creations.

Happy coloring!

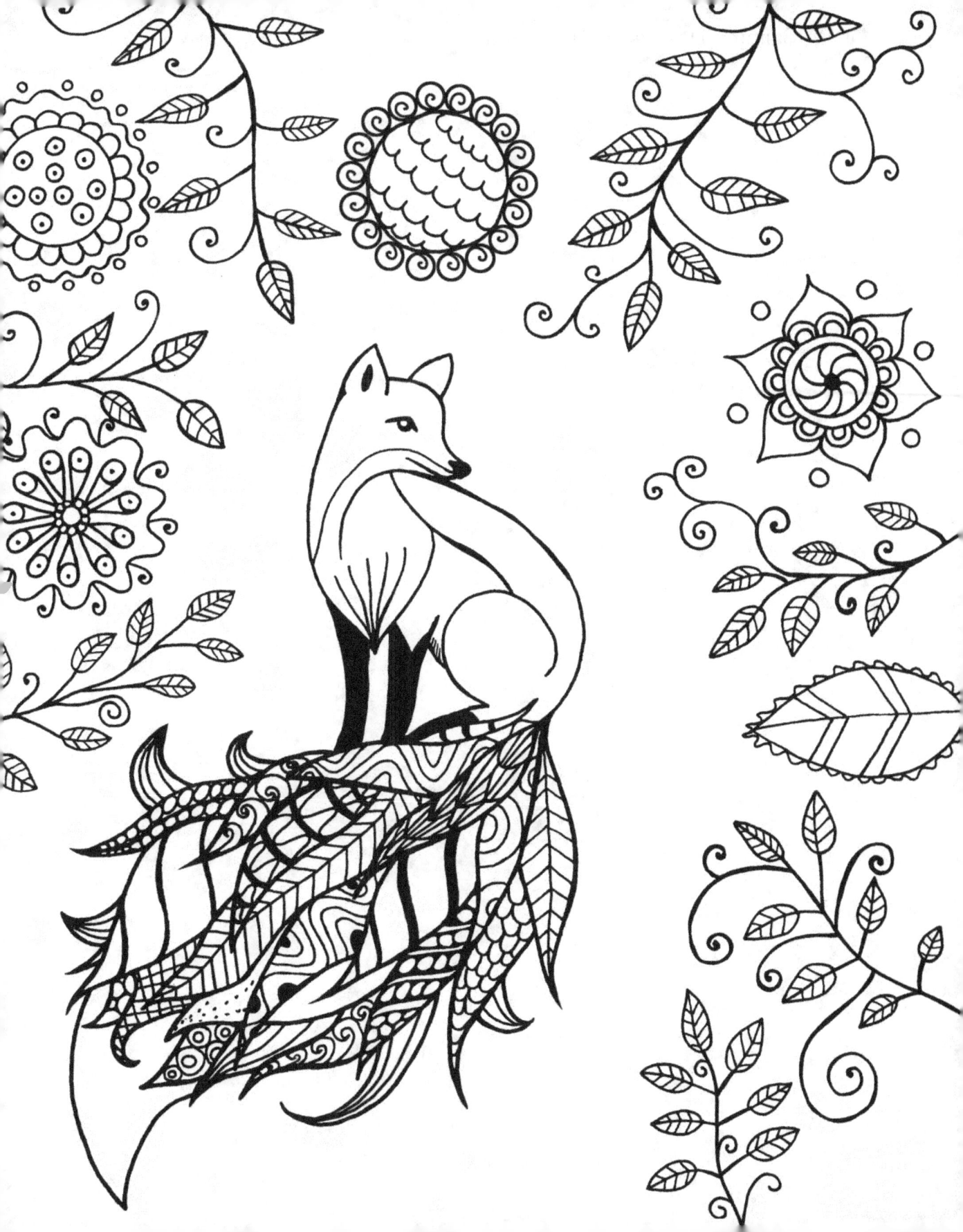

Calming Designs – 21 images for relaxation and creativity

Anca Andrei, Alexandra Andrei

Calming Designs – 21 images for relaxation and creativity

Anca Andrei, Alexandra Andrei

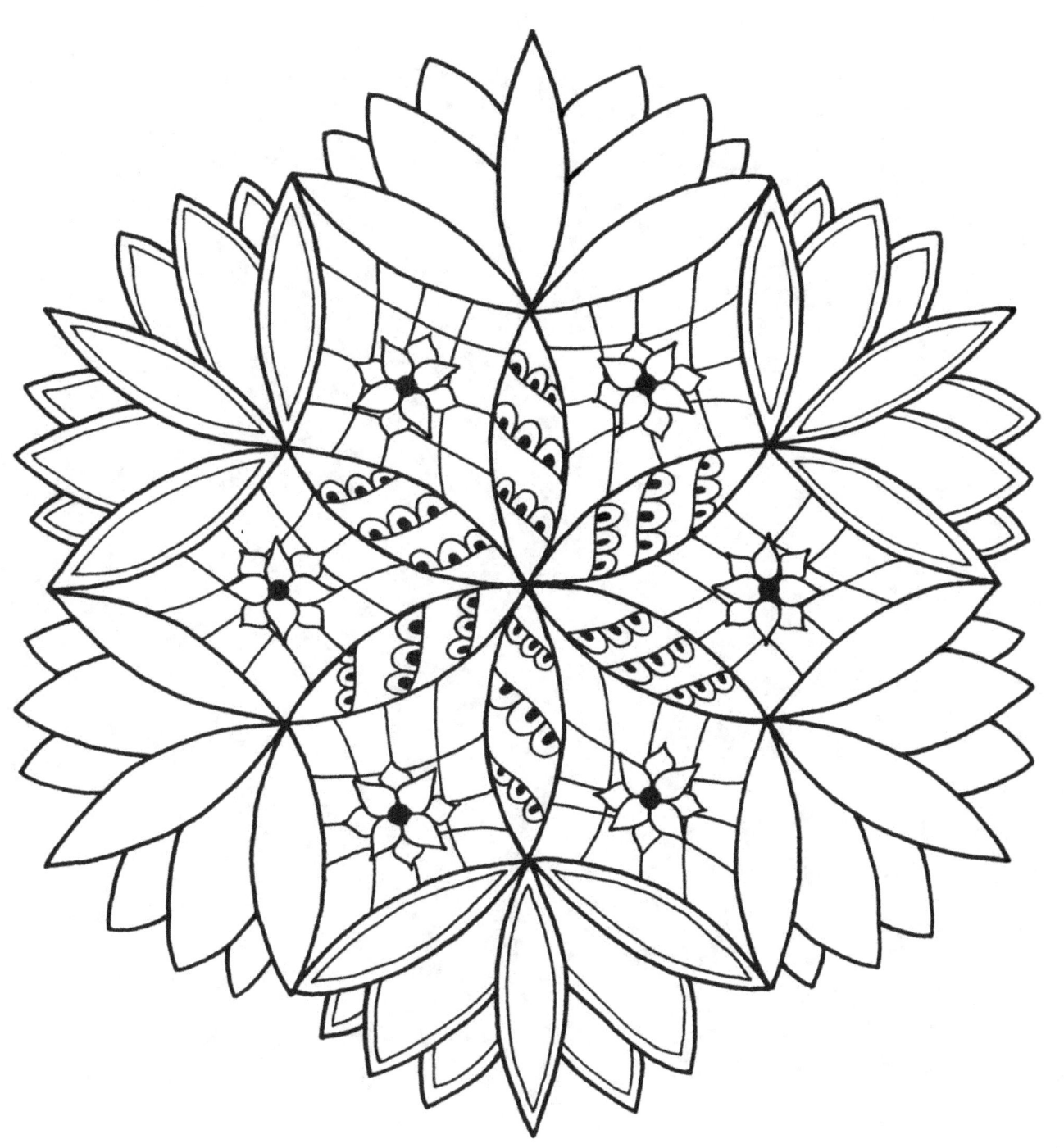

Calming Designs – 21 images for relaxation and creativity

Anca Andrei, Alexandra Andrei

Calming Designs - 21 images for relaxation and creativity

Anca Andrei, Alexandra Andrei

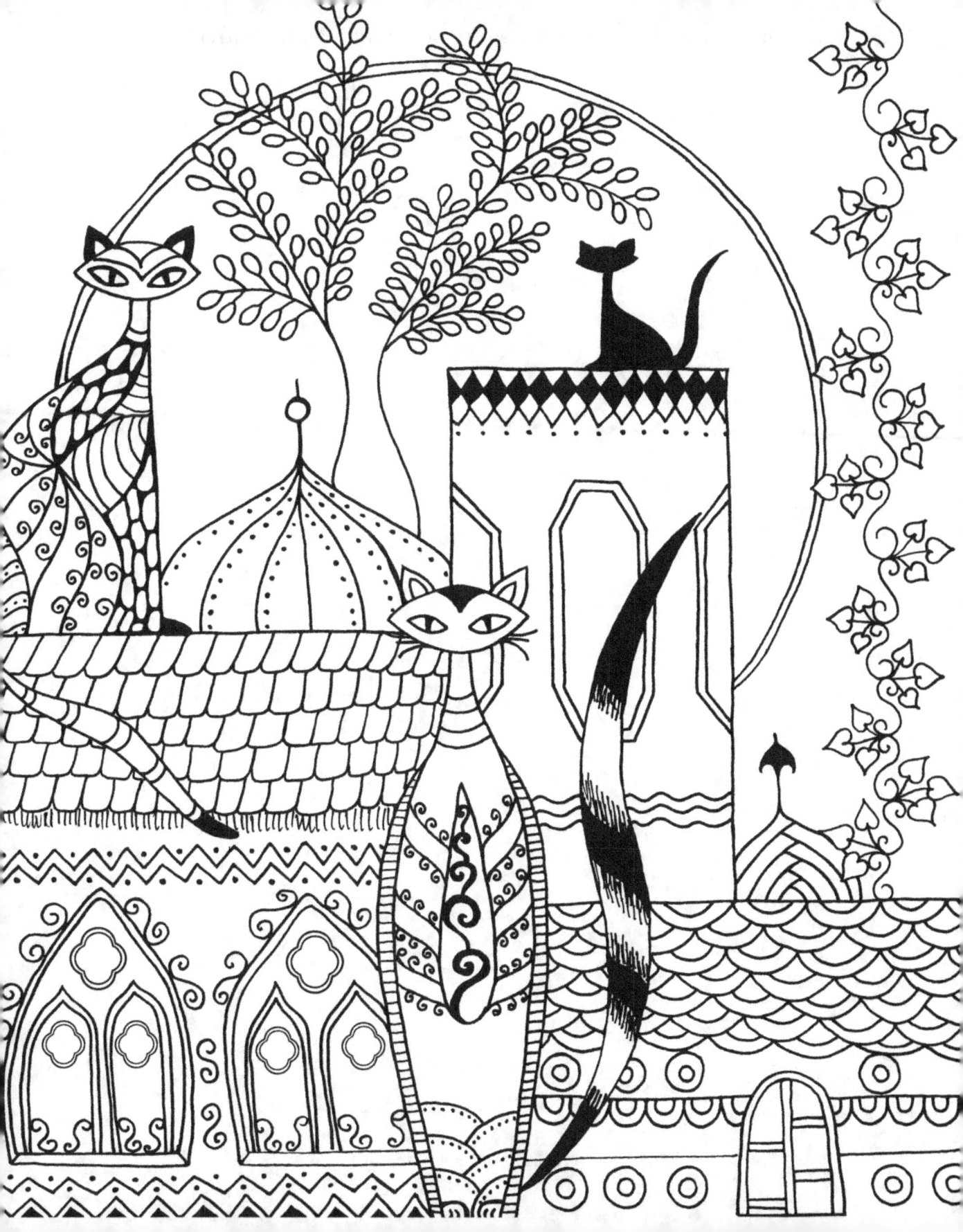

Calming Designs – 21 images for relaxation and creativity

Anca Andrei, Alexandra Andrei

Calming Designs – 21 images for relaxation and creativity

Anca Andrei, Alexandra Andrei

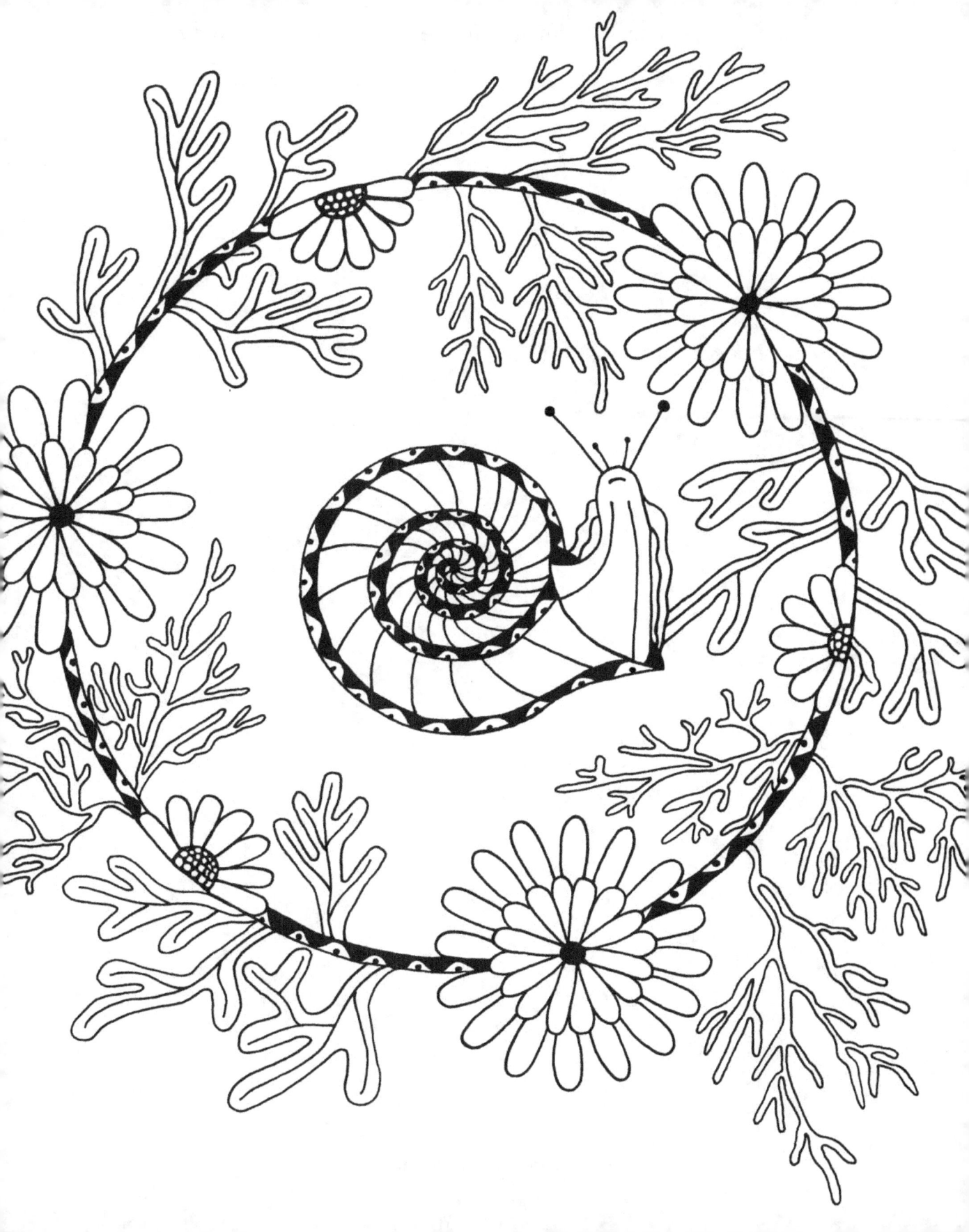

Calming Designs – 21 images for relaxation and creativity

Anca Andrei, Alexandra Andrei

Calming Designs - 21 images for relaxation and creativity

Anca Andrei, Alexandra Andrei

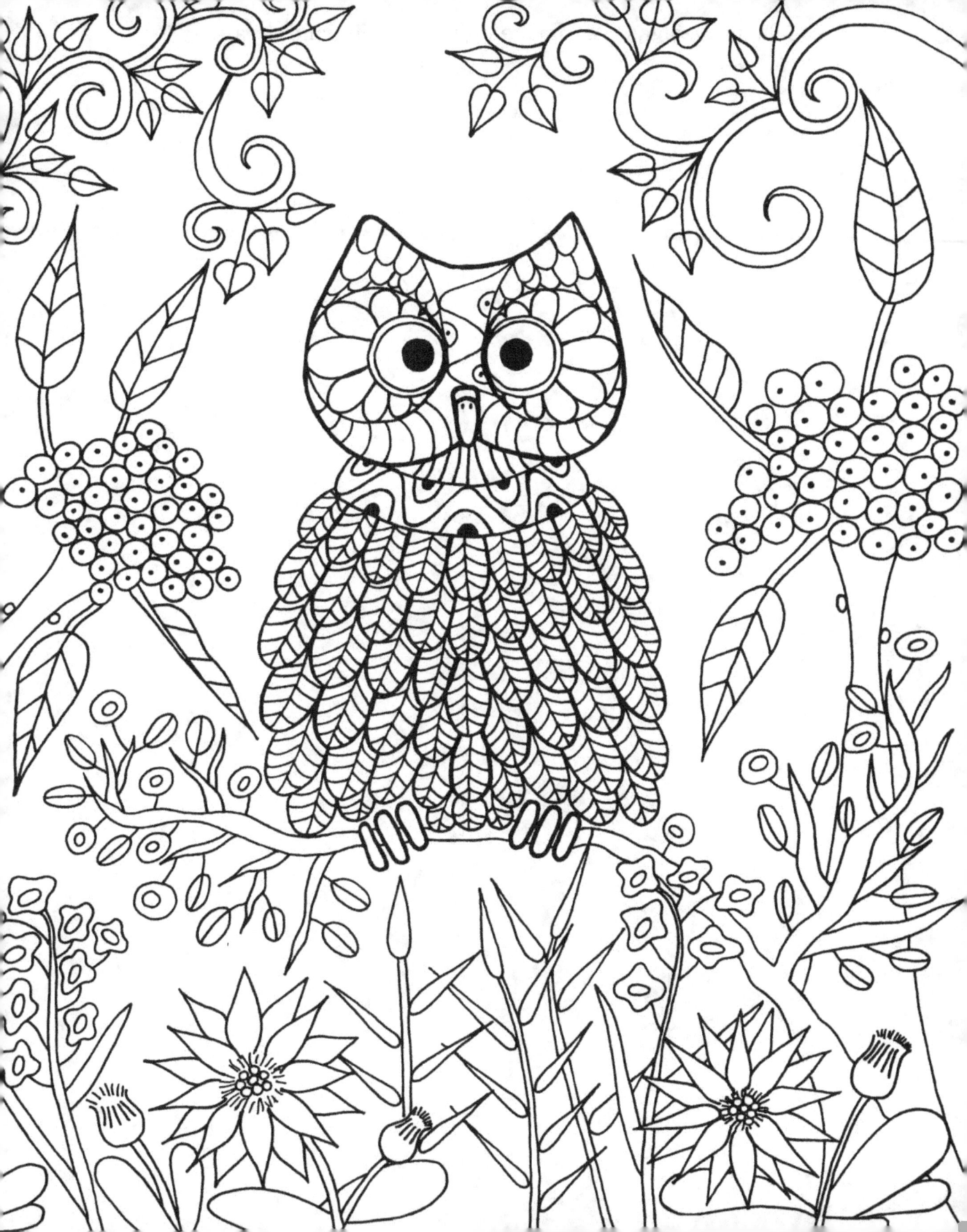

Calming Designs – 21 images for relaxation and creativity

Anca Andrei, Alexandra Andrei

Calming Designs - 21 images for relaxation and creativity

Anca Andrei, Alexandra Andrei

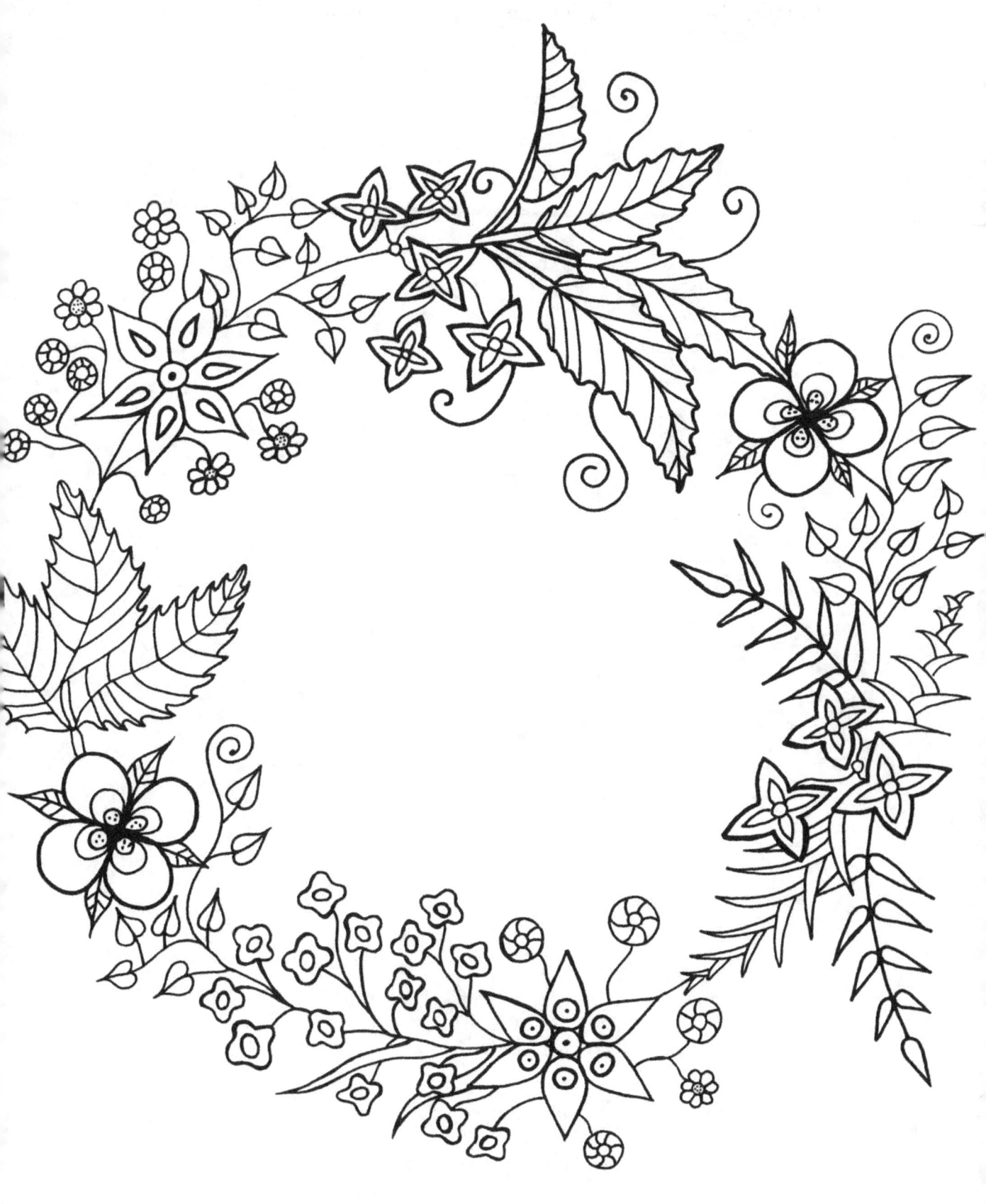

Calming Designs – 21 images for relaxation and creativity

Anca Andrei, Alexandra Andrei

Calming Designs – 21 images for relaxation and creativity

Anca Andrei, Alexandra Andrei

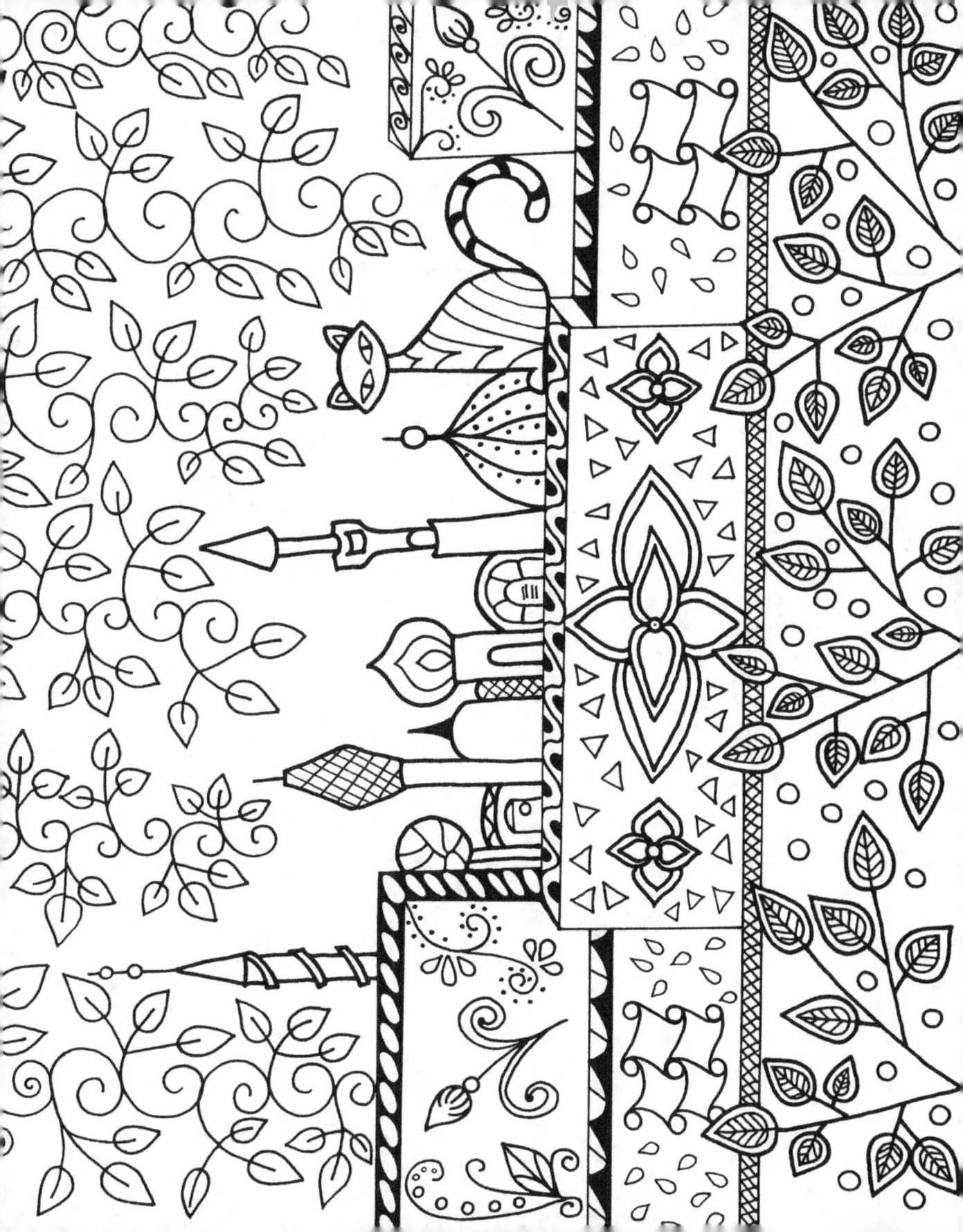

Calming Designs - 21 images for relaxation and creativity

Anca Andrei, Alexandra Andrei

Calming Designs – 21 images for relaxation and creativity

Anca Andrei, Alexandra Andrei

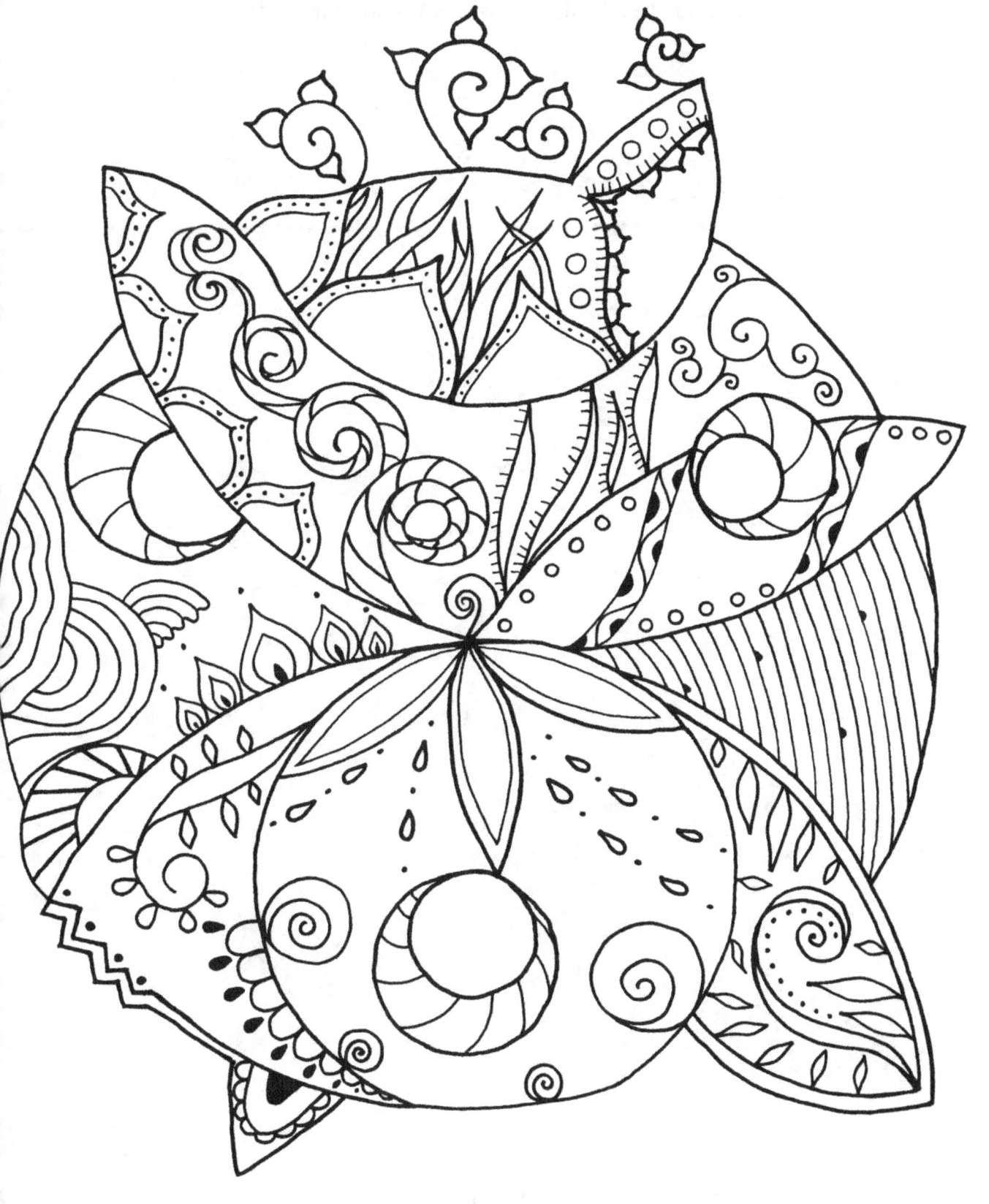

Calming Designs – 21 images for relaxation and creativity

Anca Andrei, Alexandra Andrei

Calming Designs – 21 images for relaxation and creativity

Anca Andrei, Alexandra Andrei

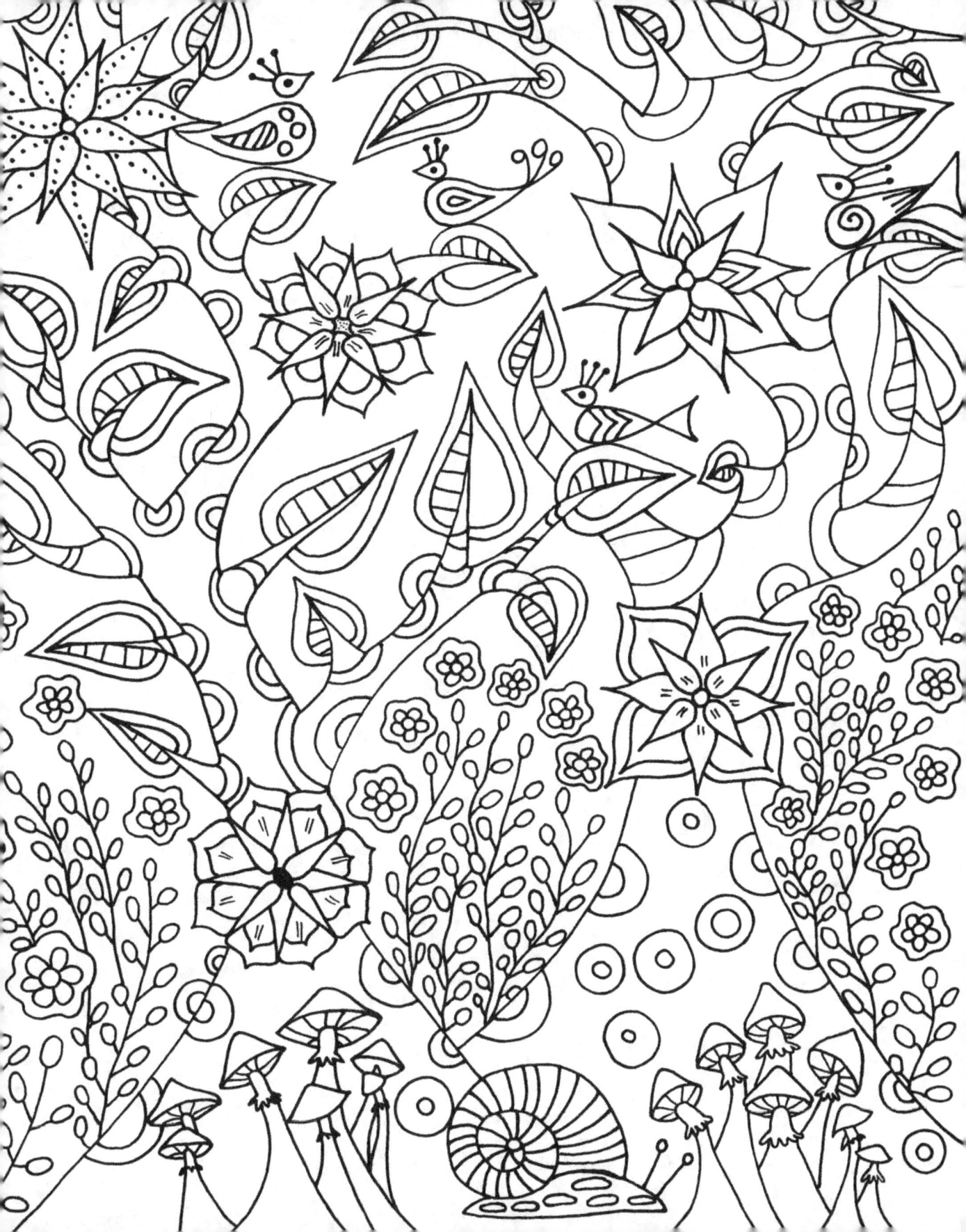

Calming Designs – 21 images for relaxation and creativity

Anca Andrei, Alexandra Andrei

Calming Designs – 21 images for relaxation and creativity

Anca Andrei, Alexandra Andrei

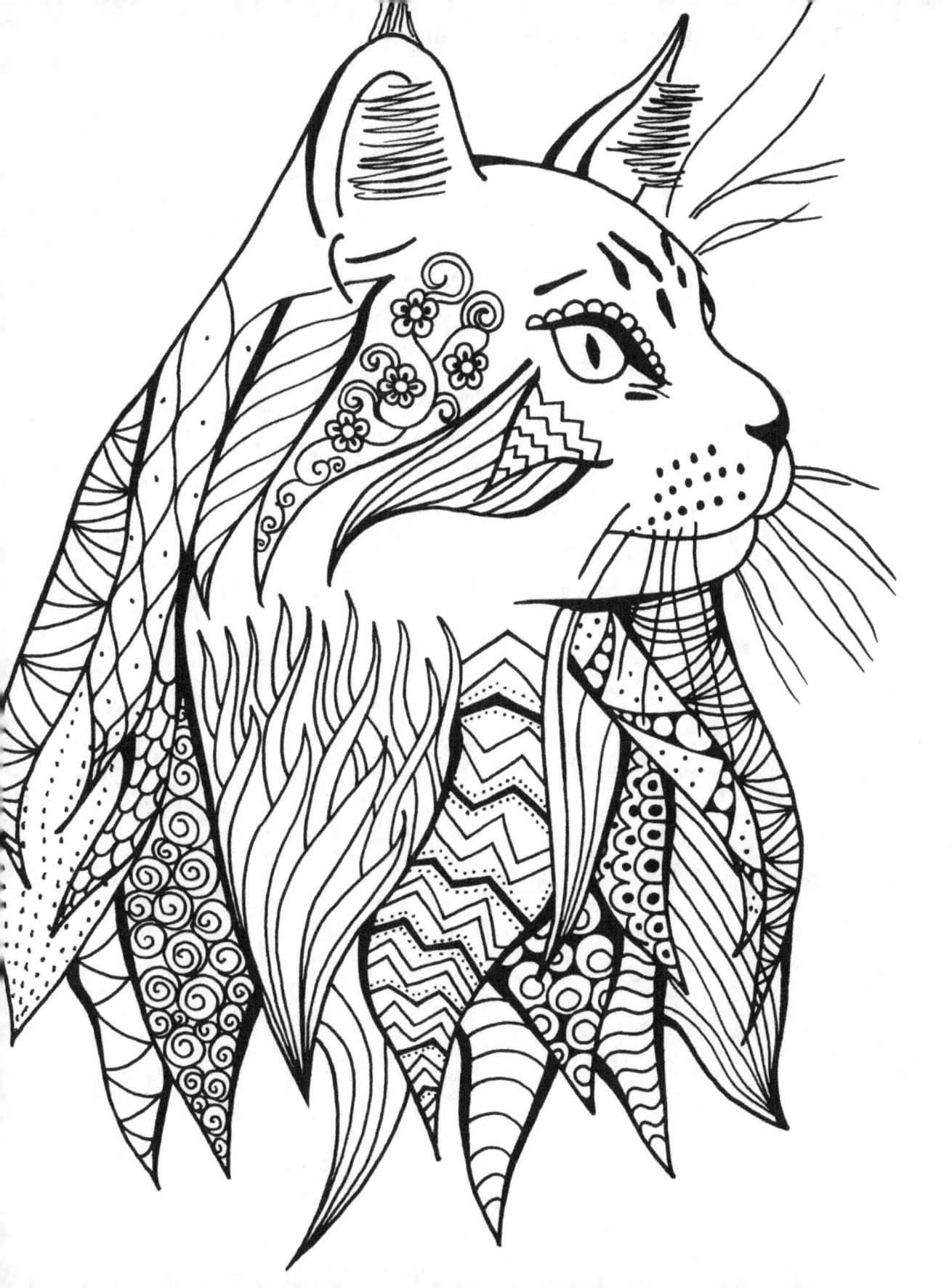

Calming Designs – 21 images for relaxation and creativity

Anca Andrei, Alexandra Andrei

Calming Designs - 21 images for relaxation and creativity

Anca Andrei, Alexandra Andrei

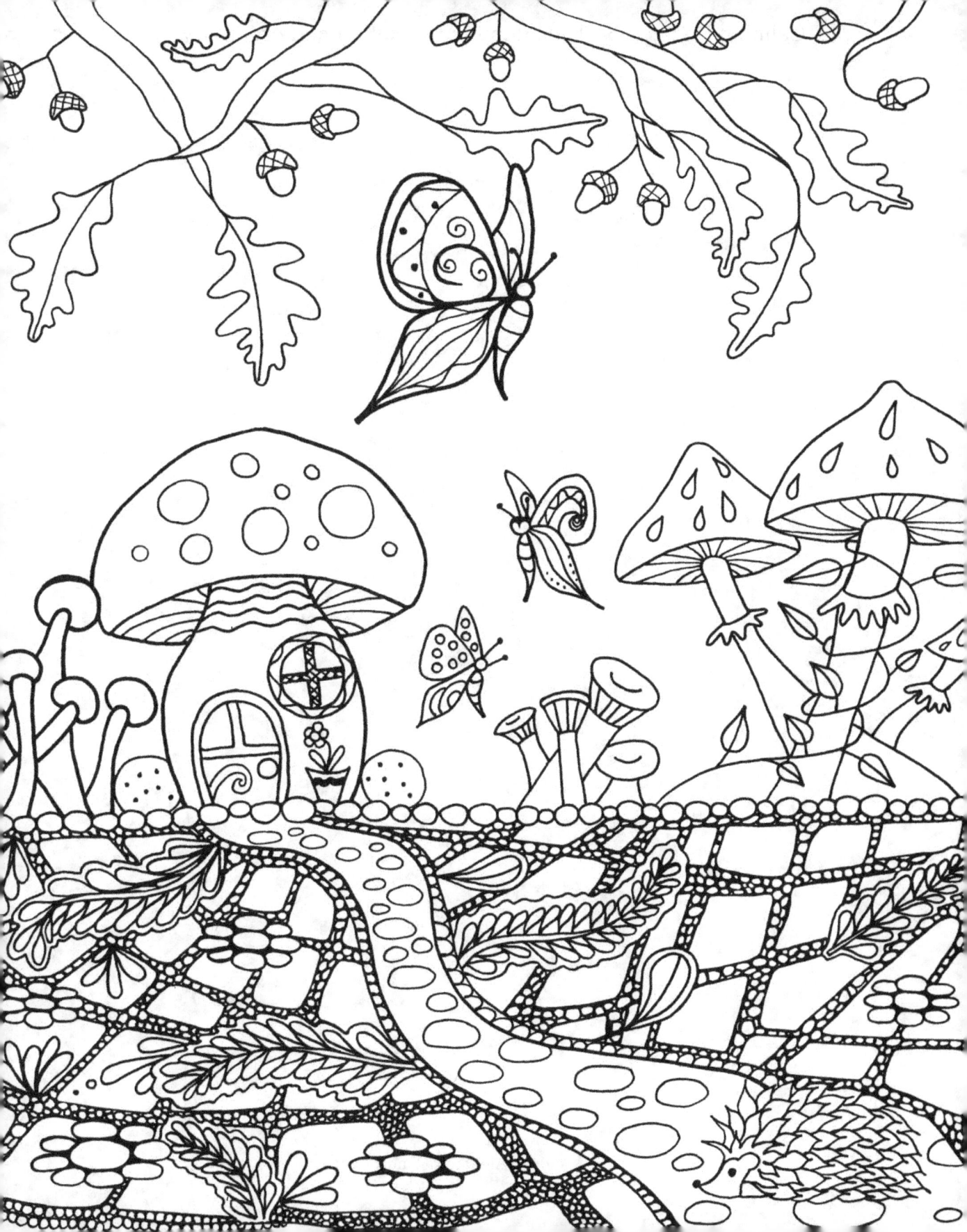

Calming Designs – 21 images for relaxation and creativity

Anca Andrei, Alexandra Andrei

Calming Designs – 21 images for relaxation and creativity

Anca Andrei, Alexandra Andrei

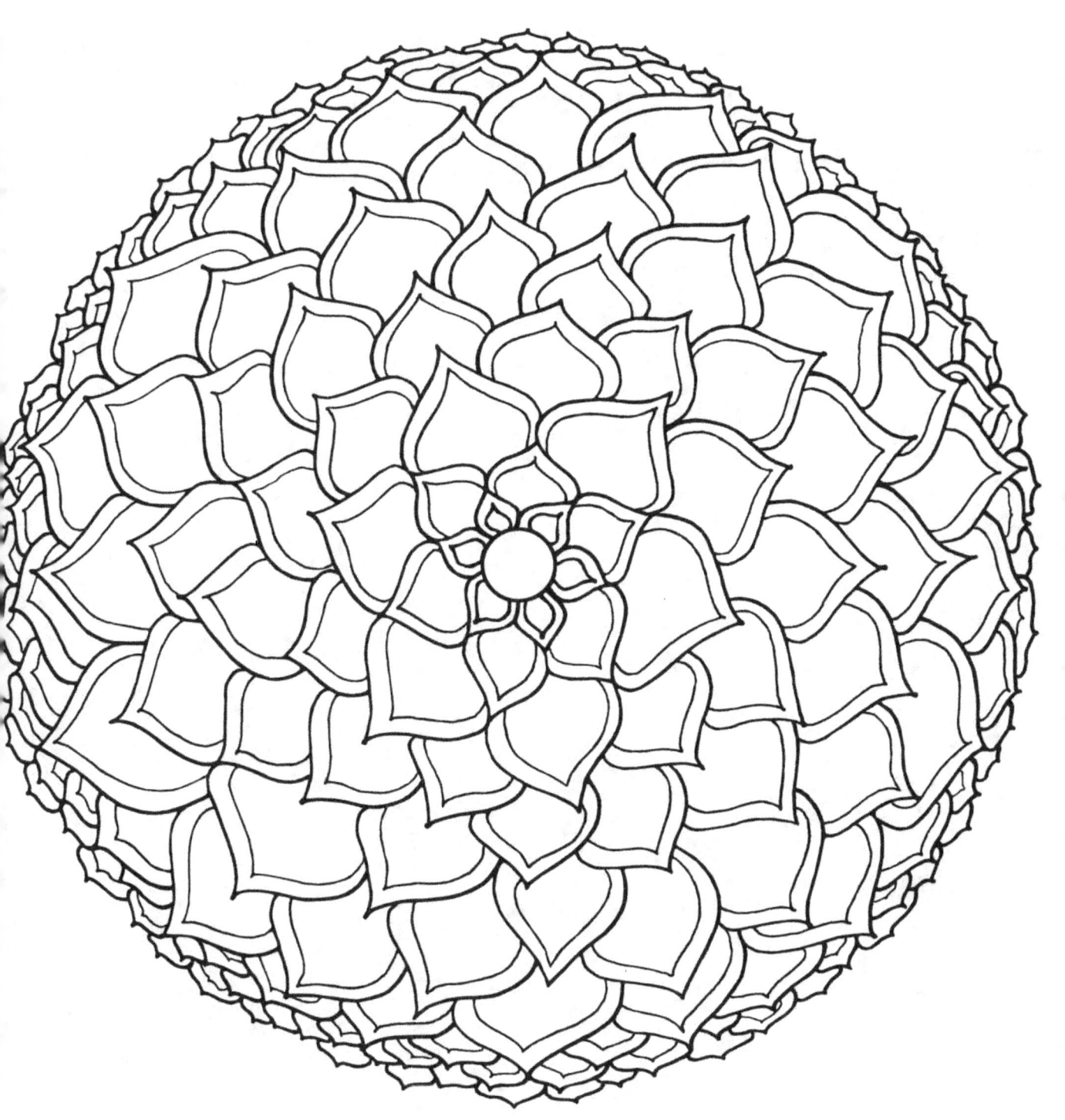

Calming Designs - 21 images for relaxation and creativity

Anca Andrei, Alexandra Andrei

Calming Designs - 21 images for relaxation and creativity

Anca Andrei, Alexandra Andrei

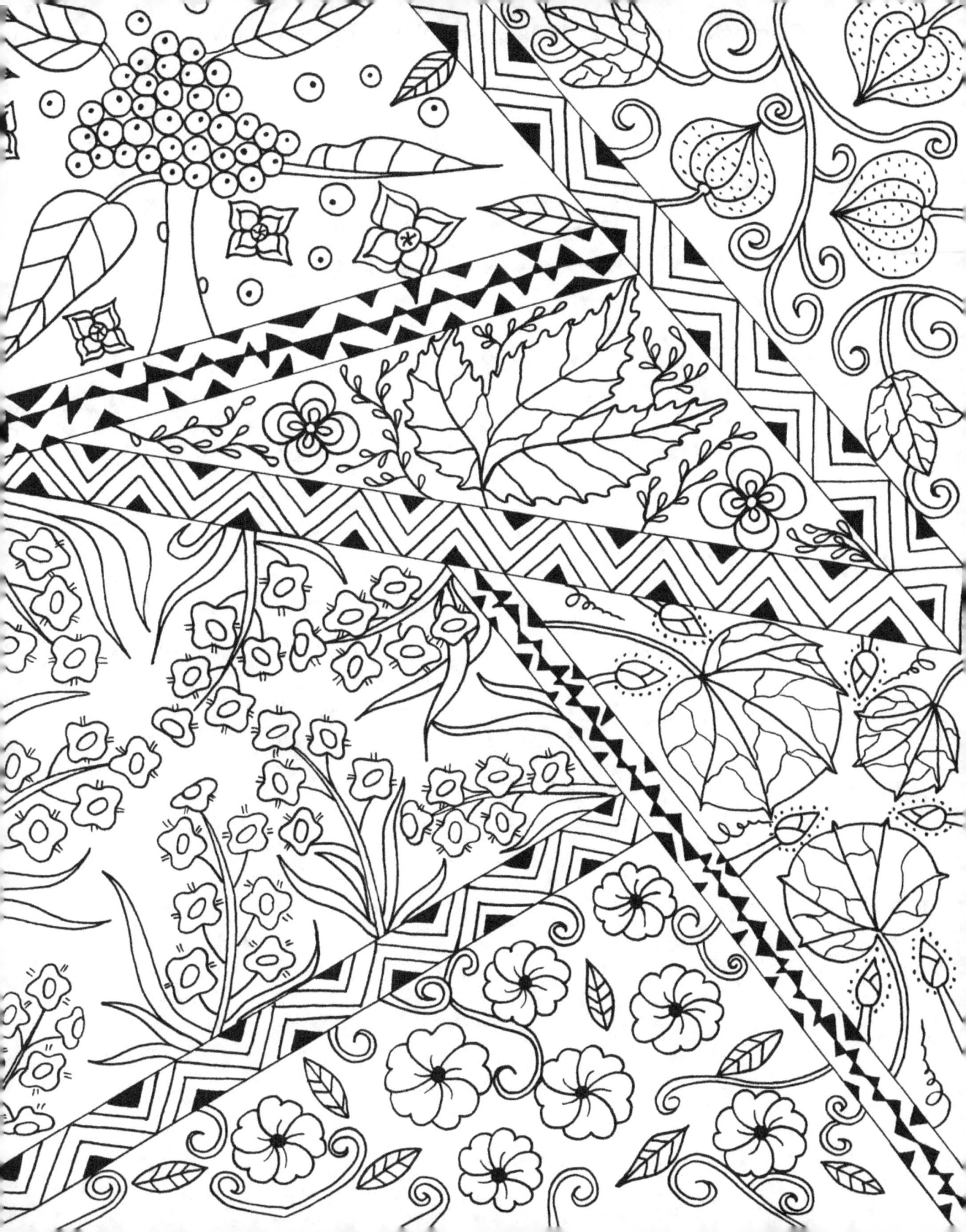

Calming Designs – 21 images for relaxation and creativity

Anca Andrei, Alexandra Andrei

Calming Designs - 21 images for relaxation and creativity

Anca Andrei, Alexandra Andrei

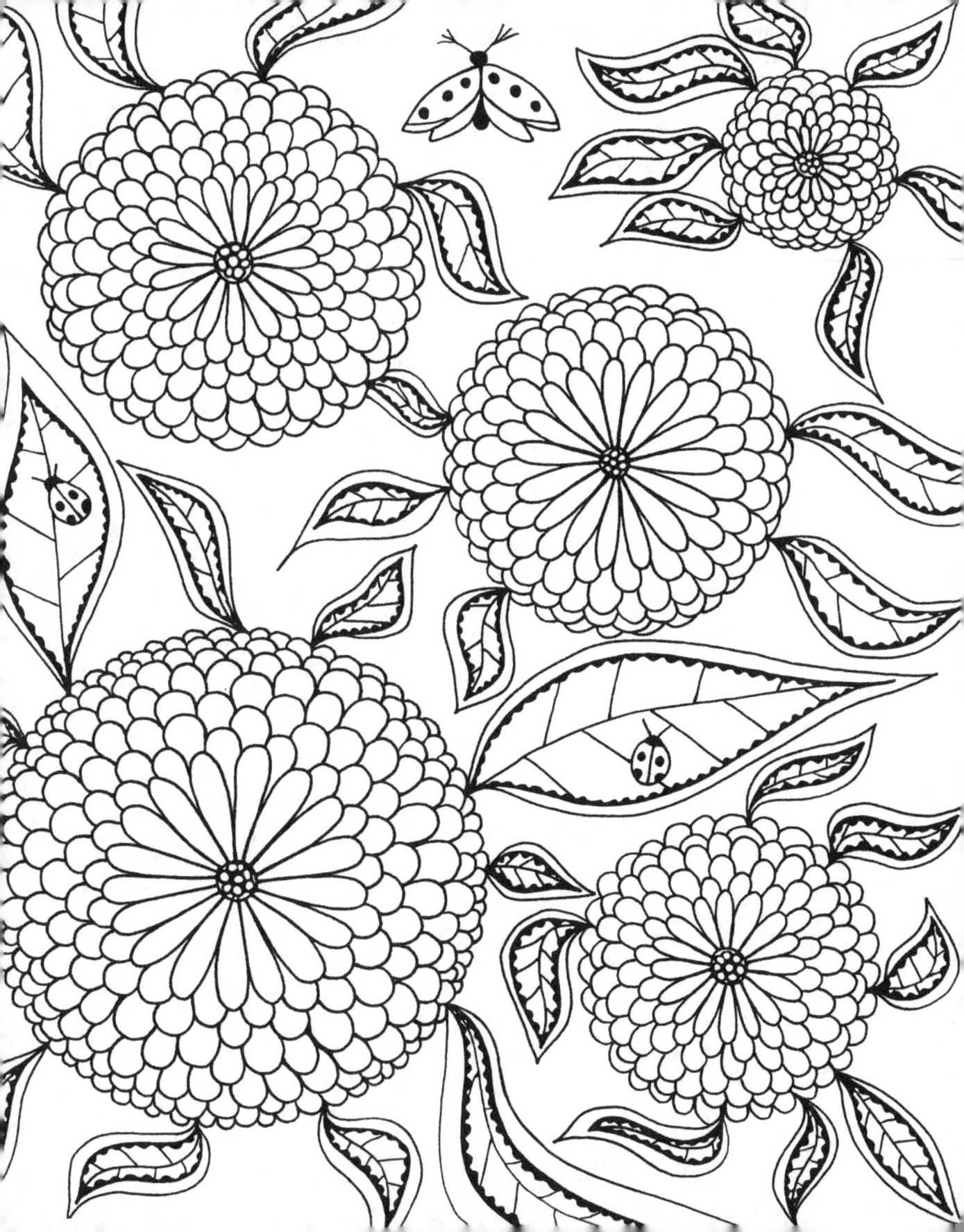

Calming Designs – 21 images for relaxation and creativity

Anca Andrei, Alexandra Andrei

Calming Designs – 21 images for relaxation and creativity

Anca Andrei, Alexandra Andrei

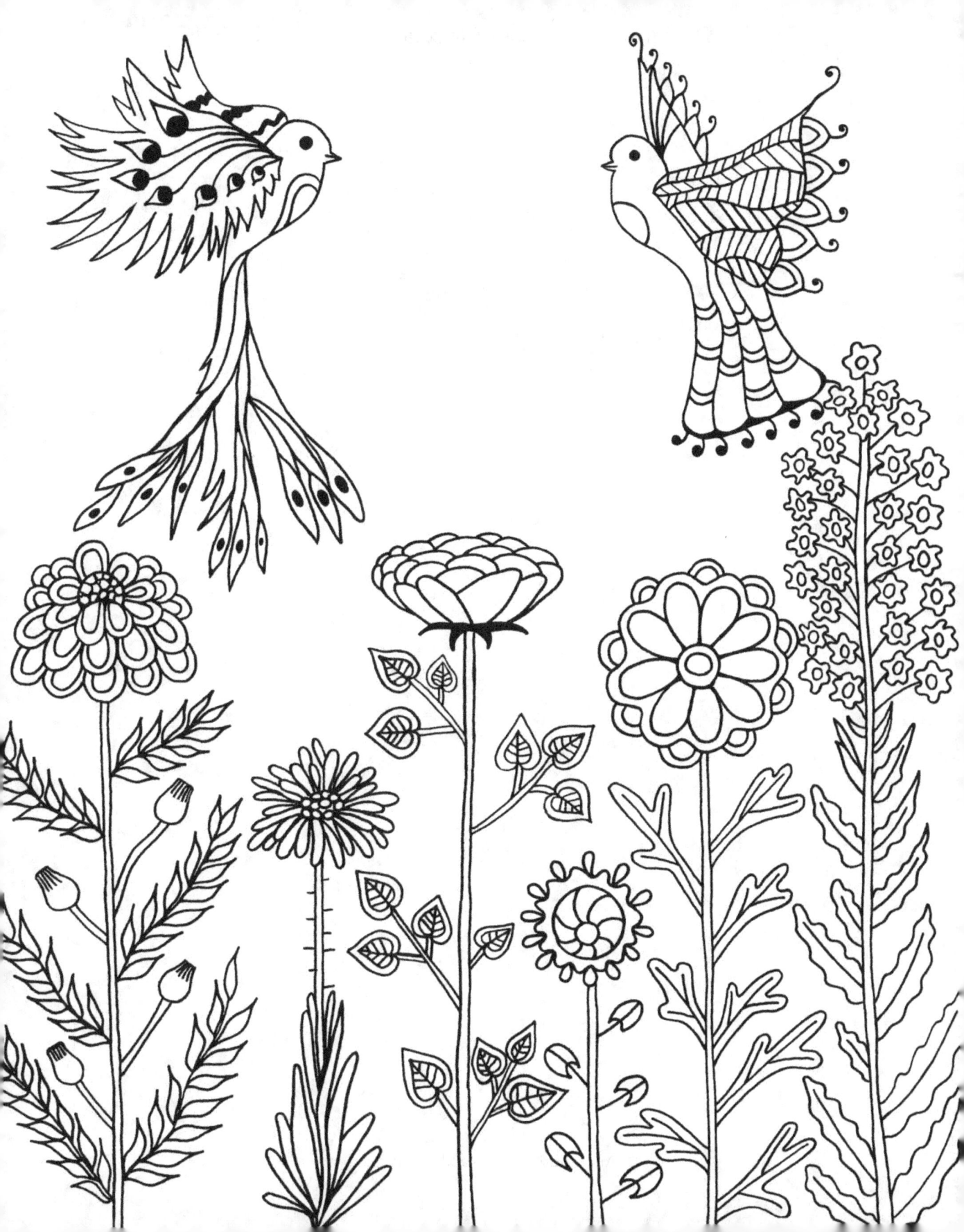

Calming Designs – 21 images for relaxation and creativity

Anca Andrei, Alexandra Andrei

Calming Designs – 21 images for relaxation and creativity

Anca Andrei, Alexandra Andrei

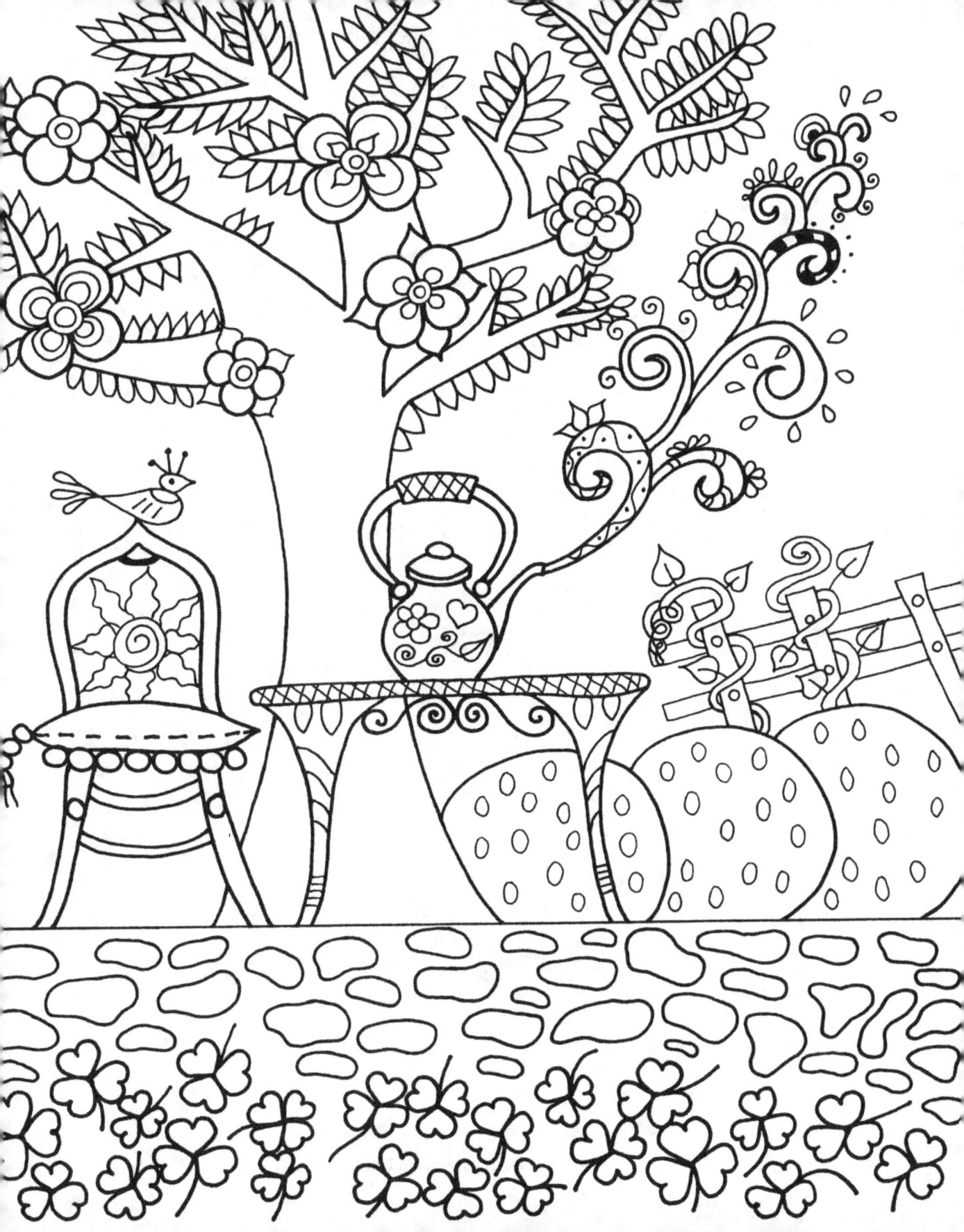

Calming Designs - 21 images for relaxation and creativity

Anca Andrei, Alexandra Andrei

Calming Designs – 21 images for relaxation and creativity

Anca Andrei, Alexandra Andrei

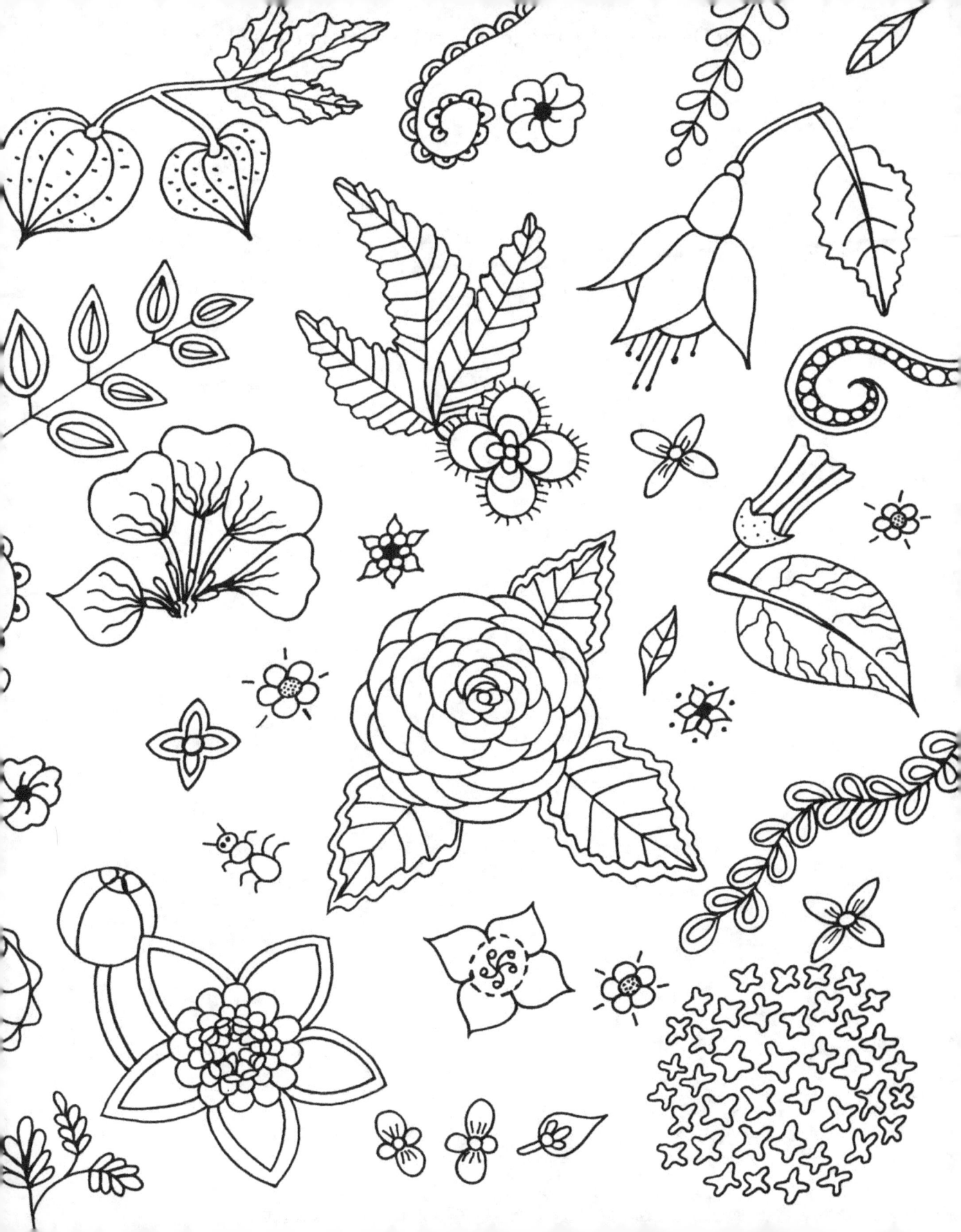

Calming Designs - 21 images for relaxation and creativity

Anca Andrei, Alexandra Andrei

Calming Designs – 21 images for relaxation and creativity

Anca Andrei, Alexandra Andrei

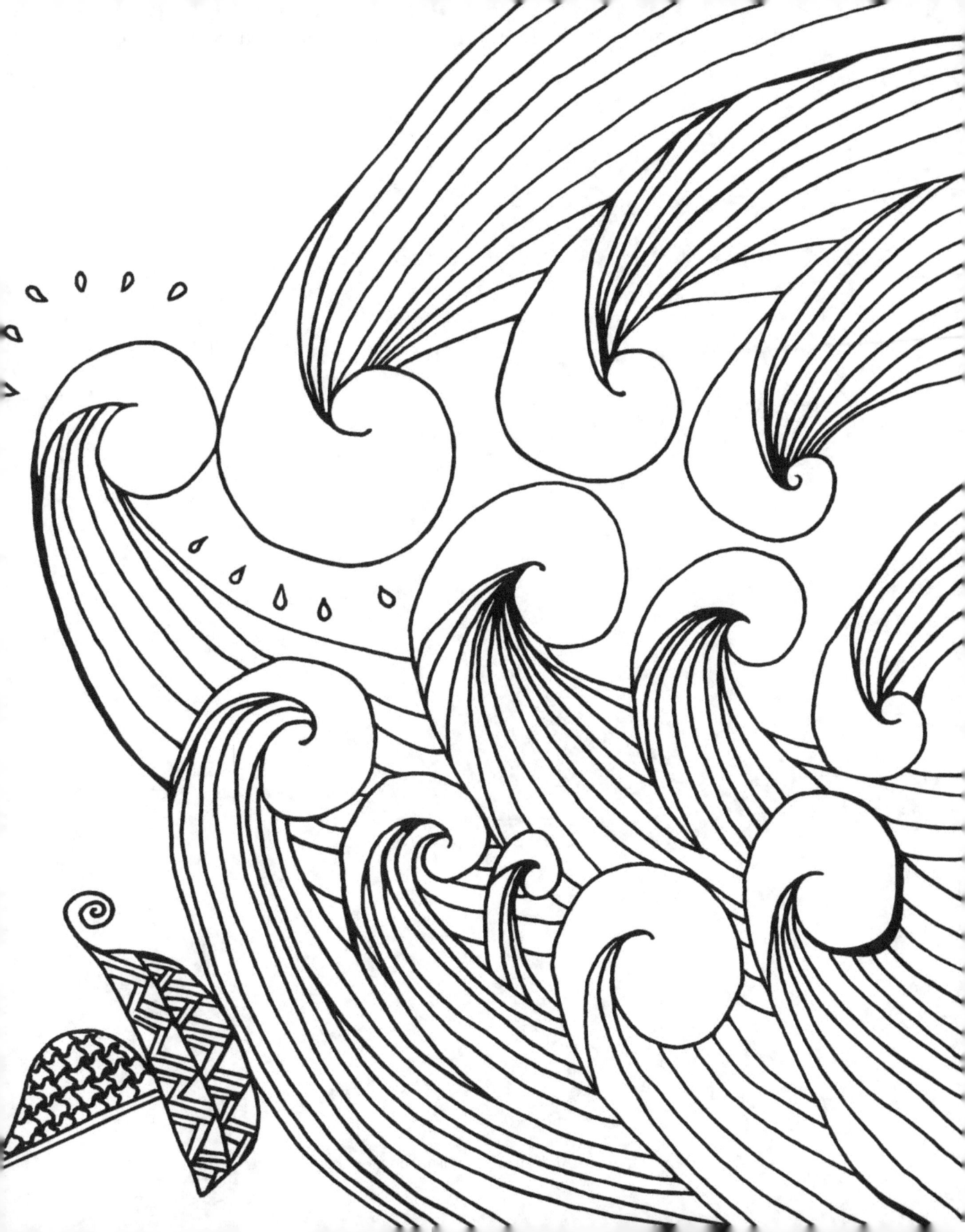

Calming Designs – 21 images for relaxation and creativity

Anca Andrei, Alexandra Andrei

Calming Designs – 21 images for relaxation and creativity

Anca Andrei, Alexandra Andrei

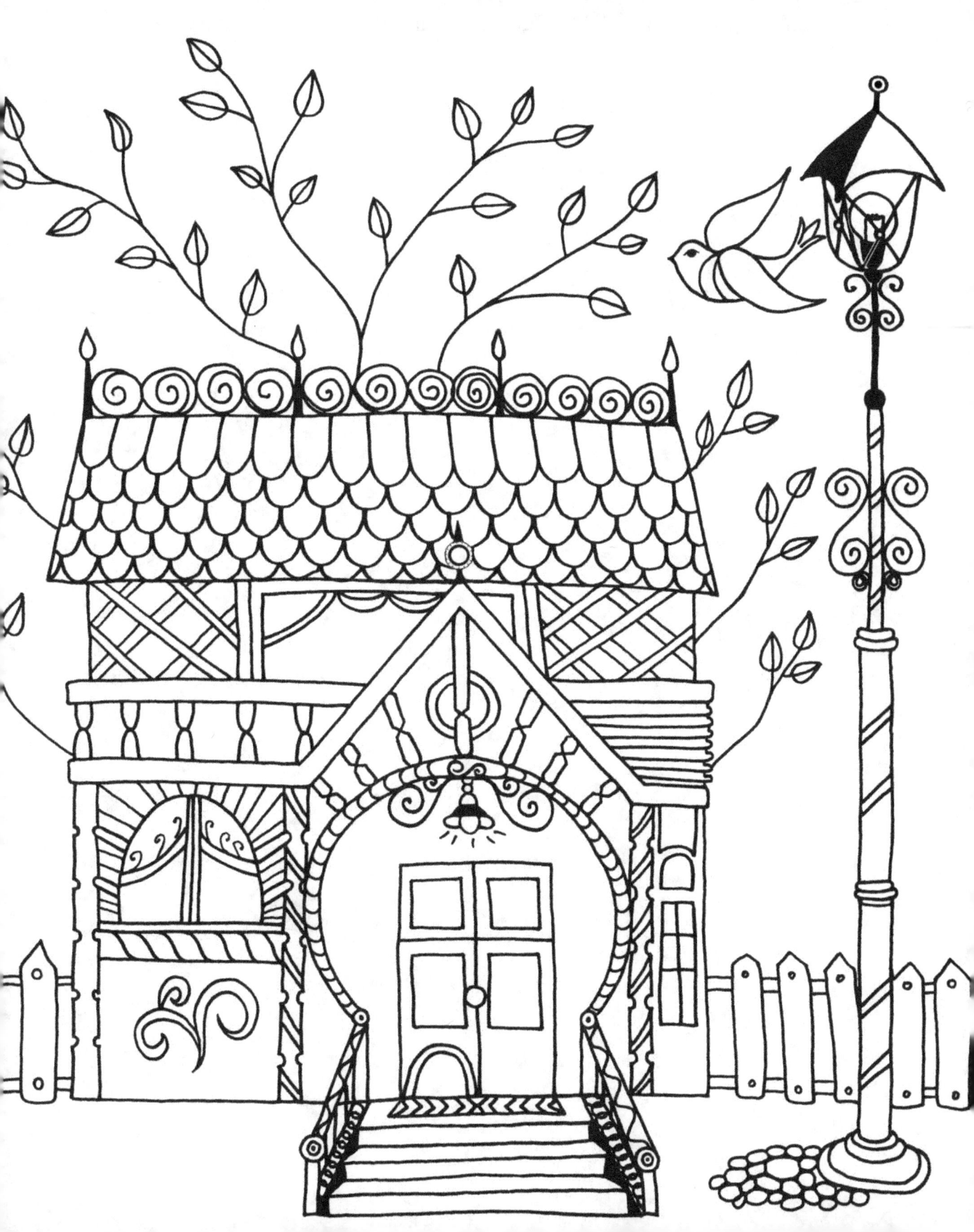

Calming Designs – 21 images for relaxation and creativity

Anca Andrei, Alexandra Andrei

Calming Designs – 21 images for relaxation and creativity

Anca Andrei, Alexandra Andrei

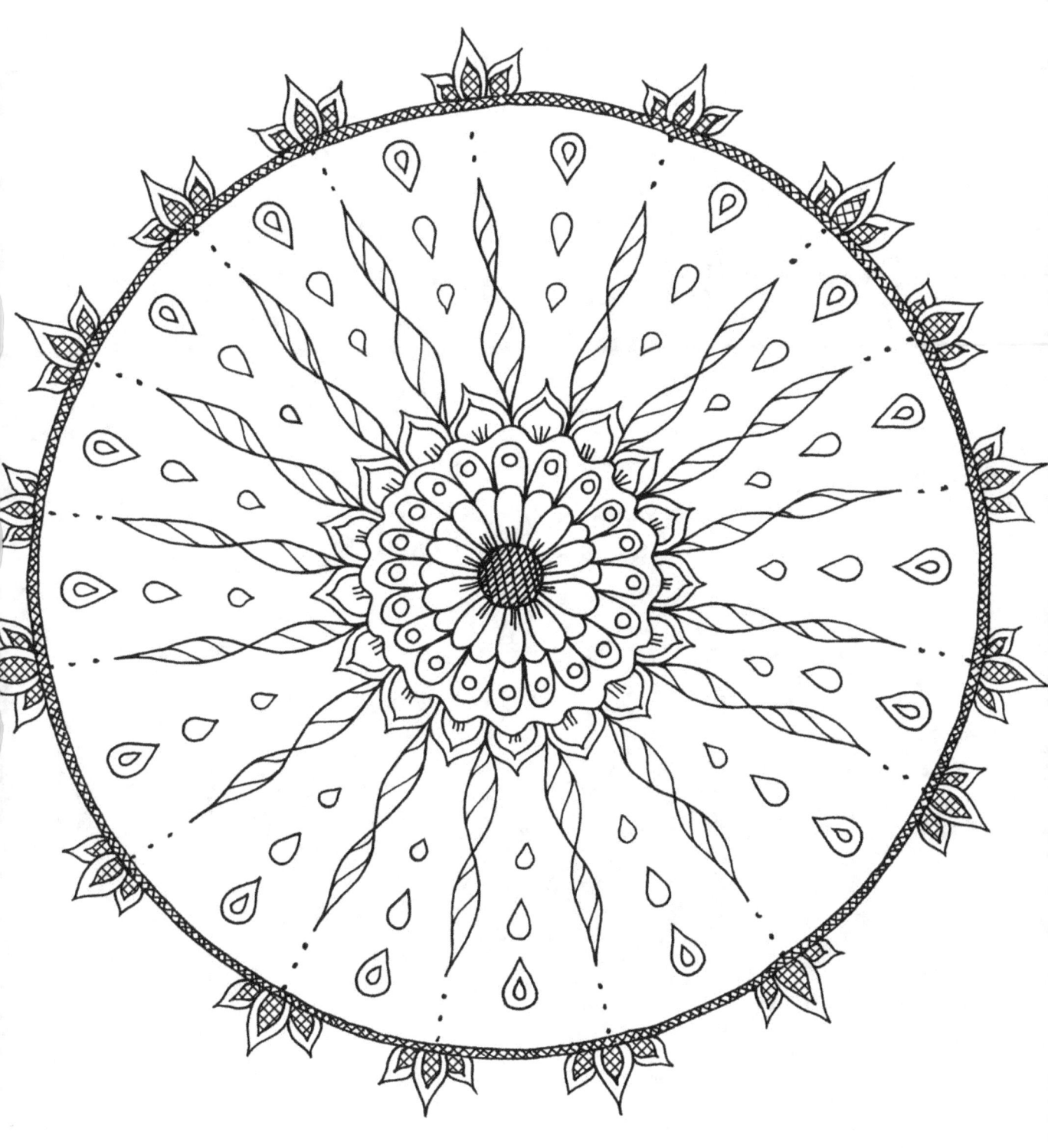

Calming Designs – 21 images for relaxation and creativity

Anca Andrei, Alexandra Andrei

Calming Designs – 21 images for relaxation and creativity

Anca Andrei, Alexandra Andrei

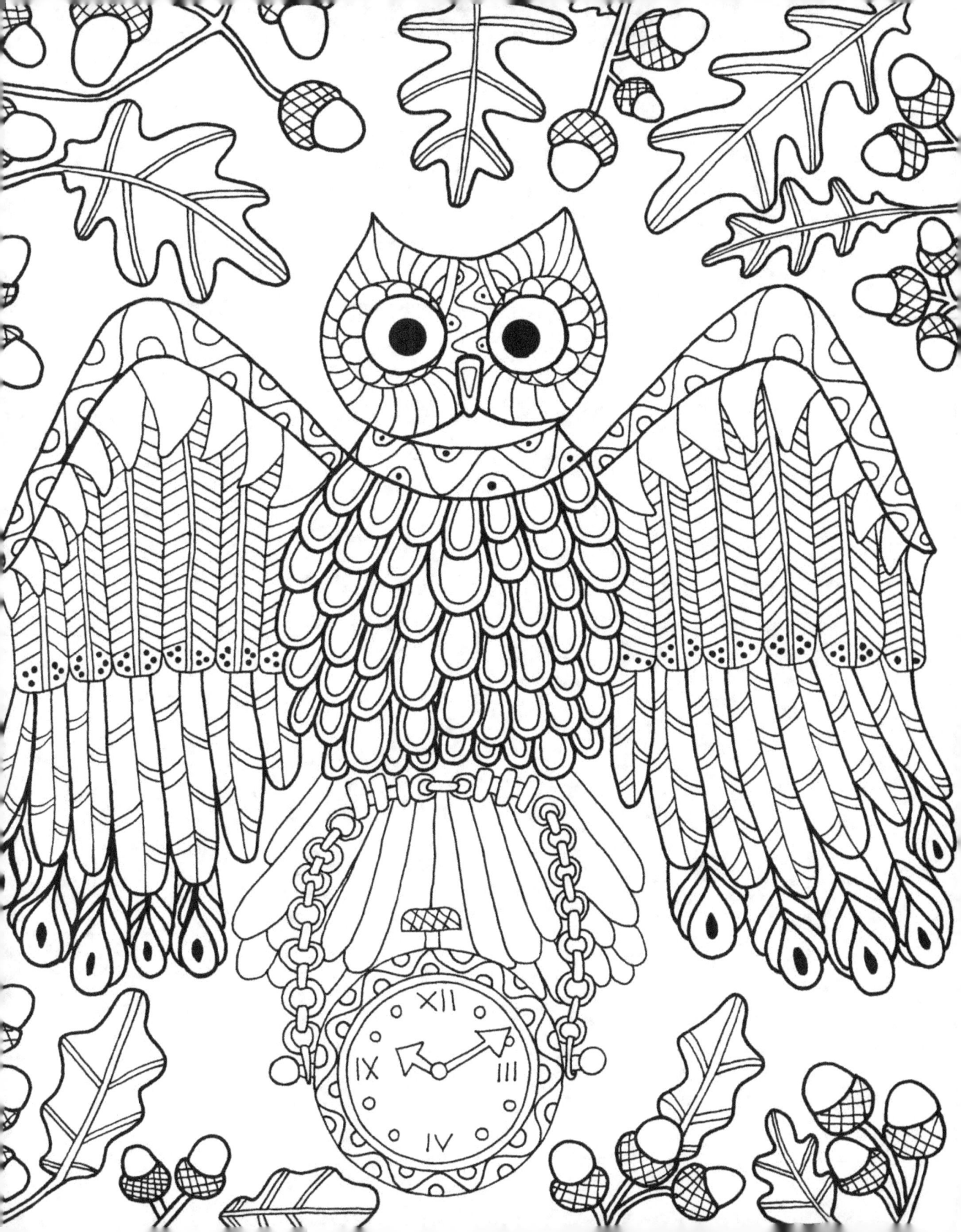

Calming Designs - 21 images for relaxation and creativity

Anca Andrei, Alexandra Andrei

www.ingramcontent.com/pod-product-compliance
Lightning Source LLC
Chambersburg PA
CBHW081207180526
45170CB00006B/2242